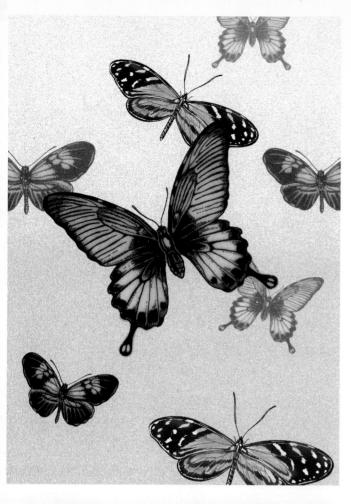

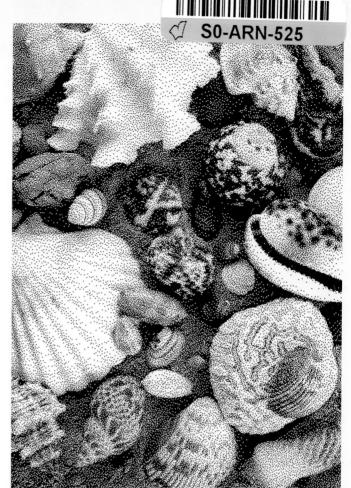

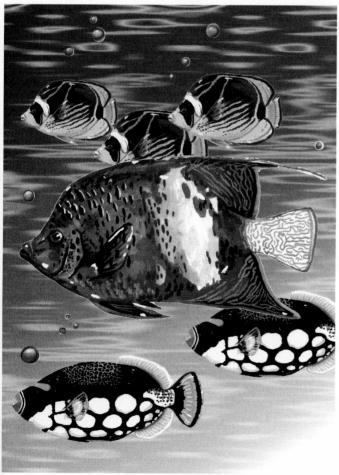

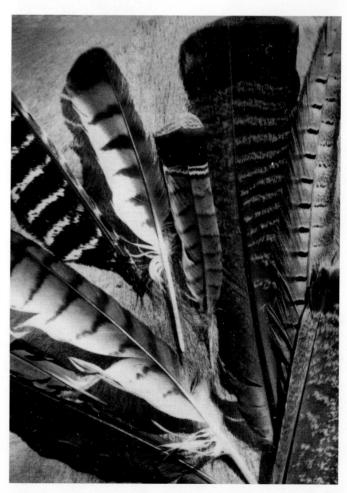

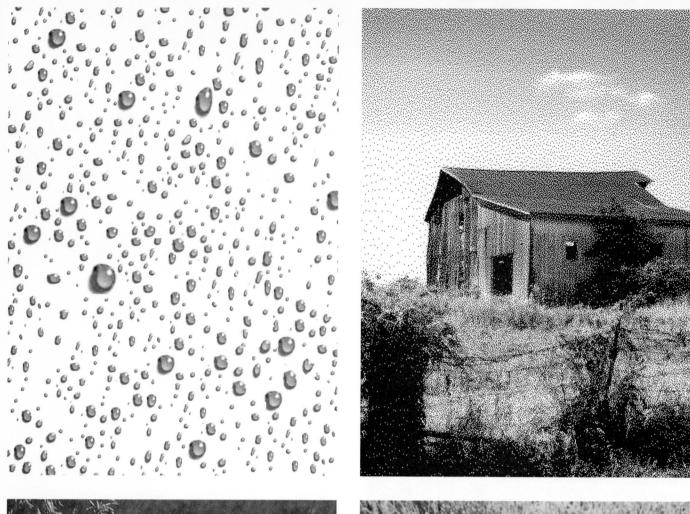

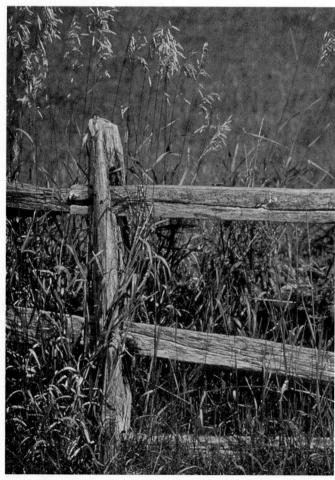

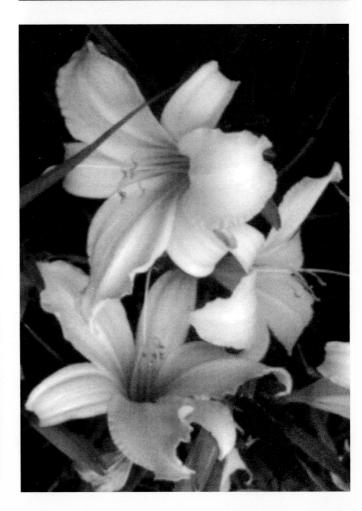

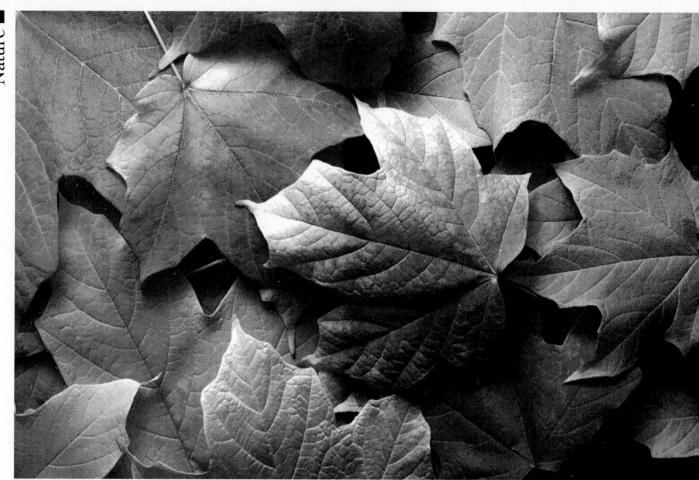

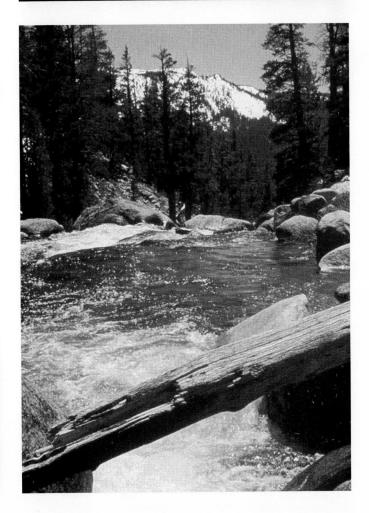

Outdoors and Sports

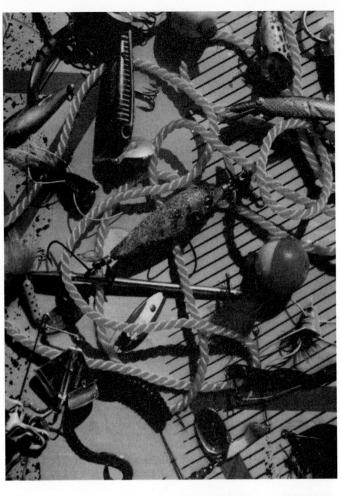

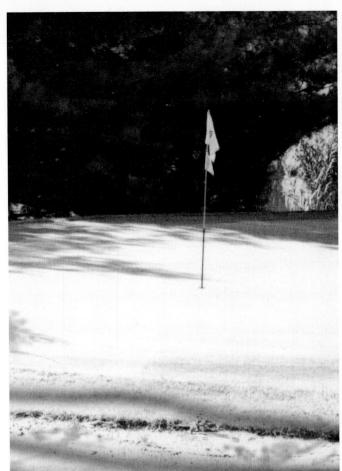

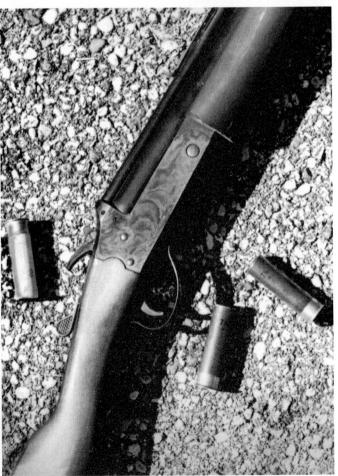

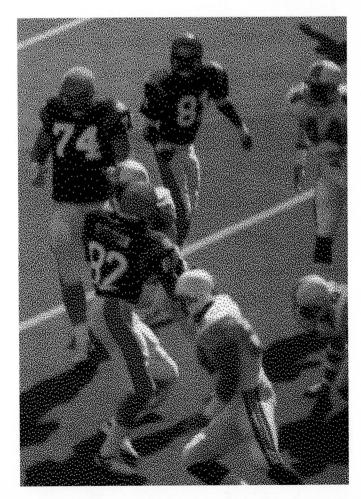

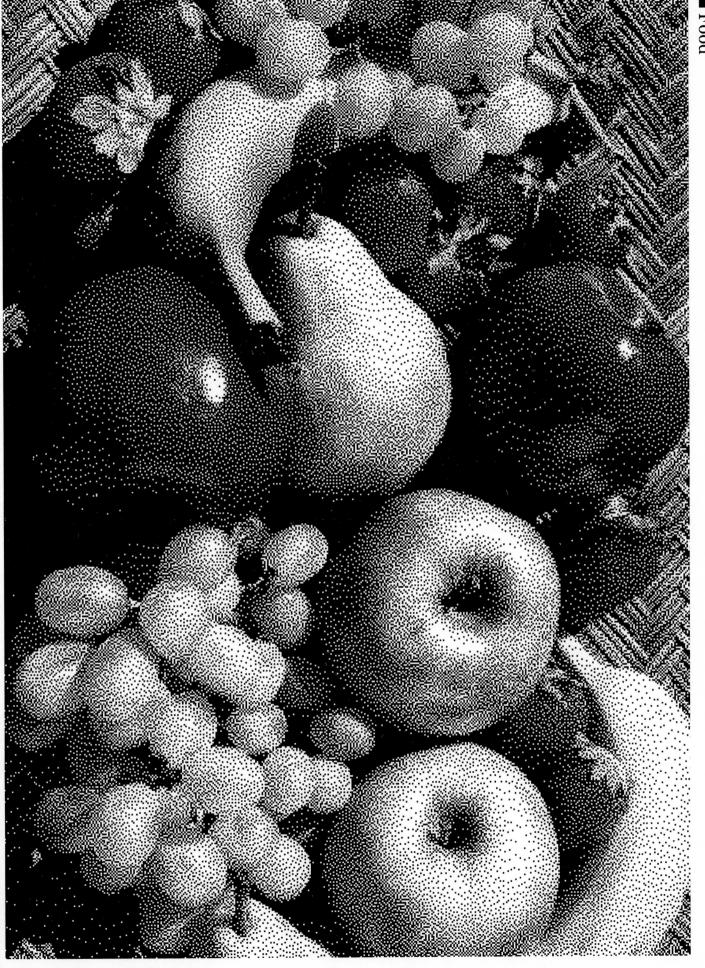

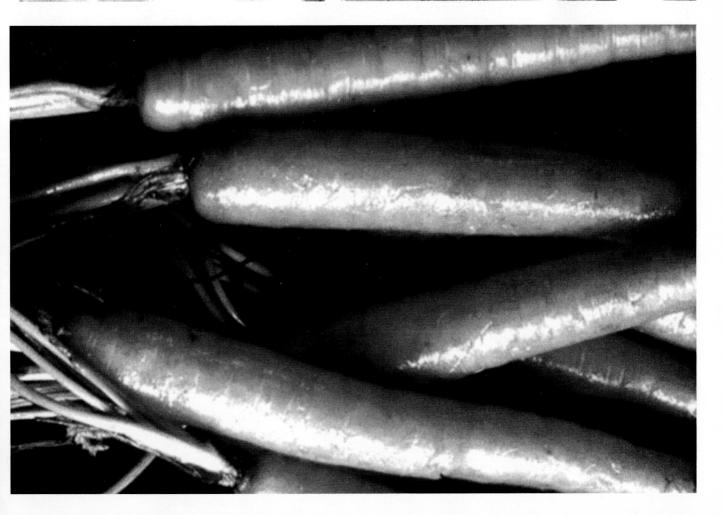

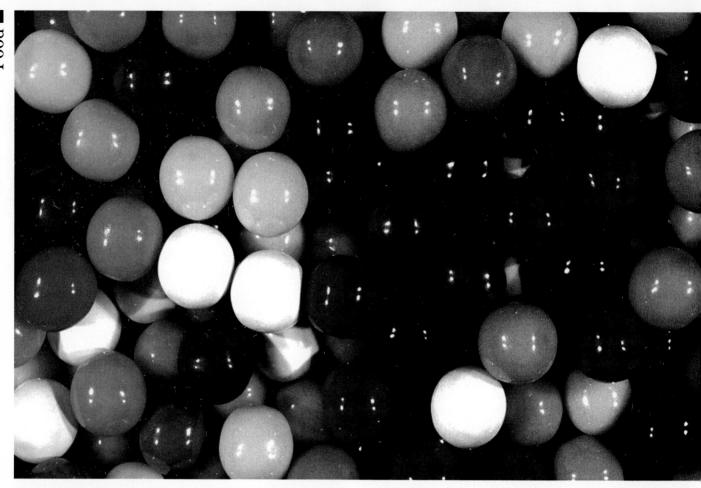

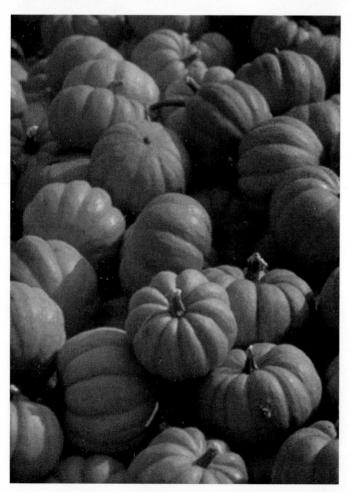

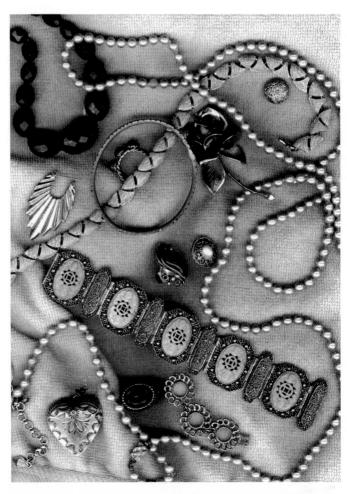

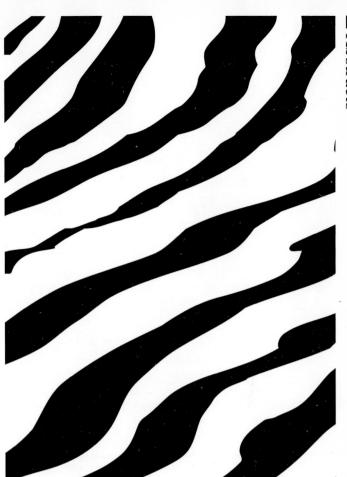

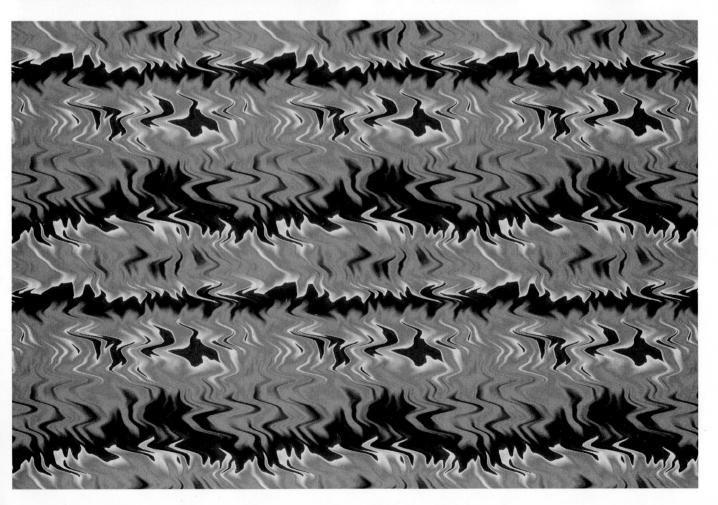

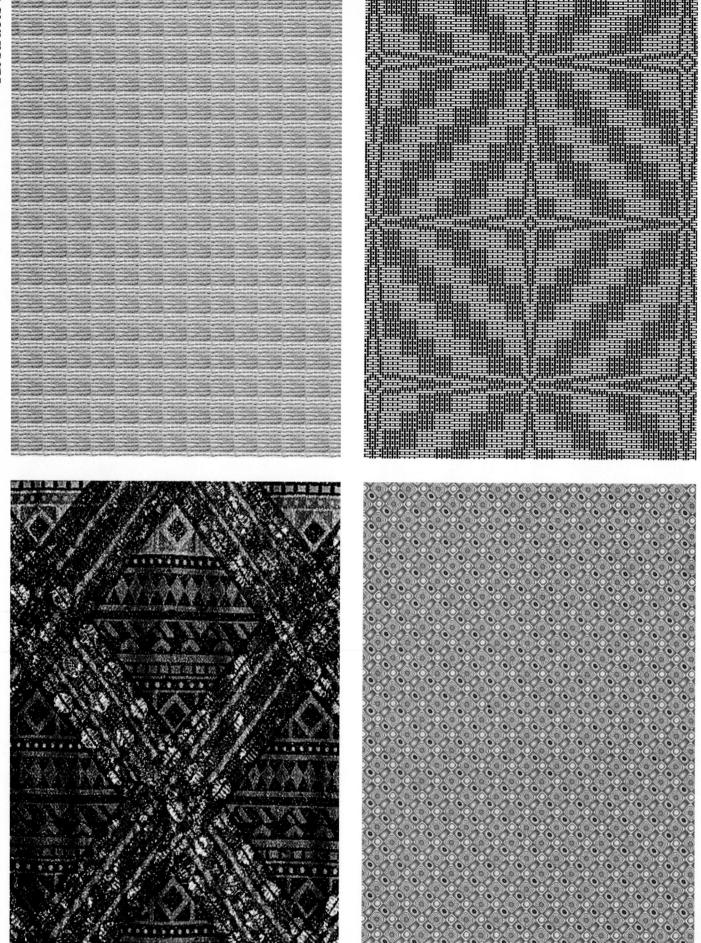

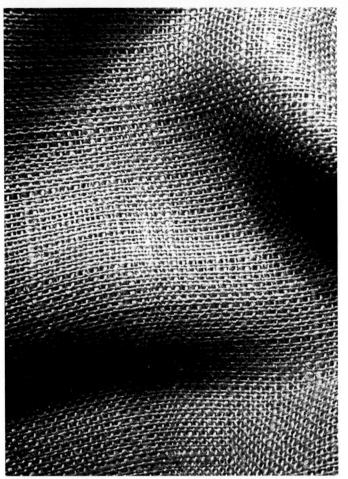

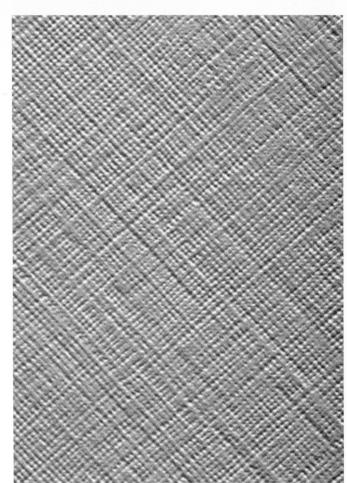

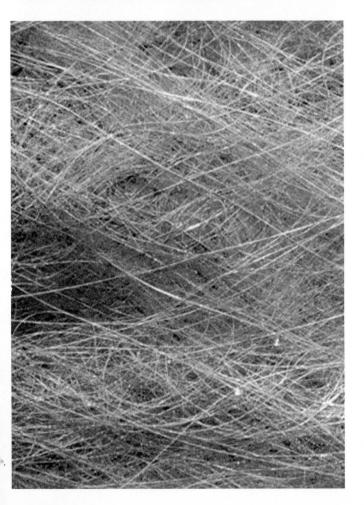

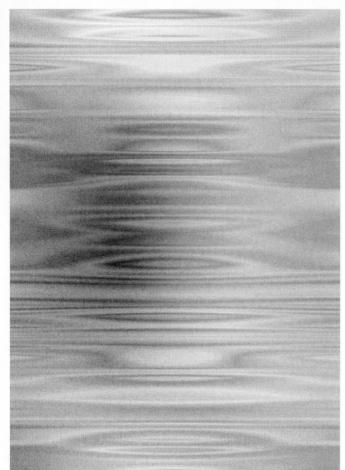

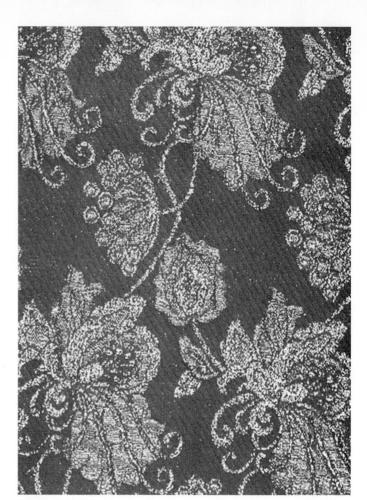

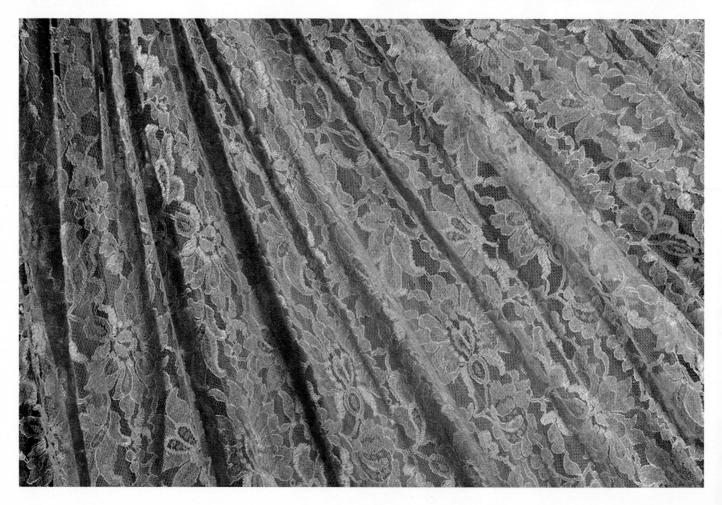

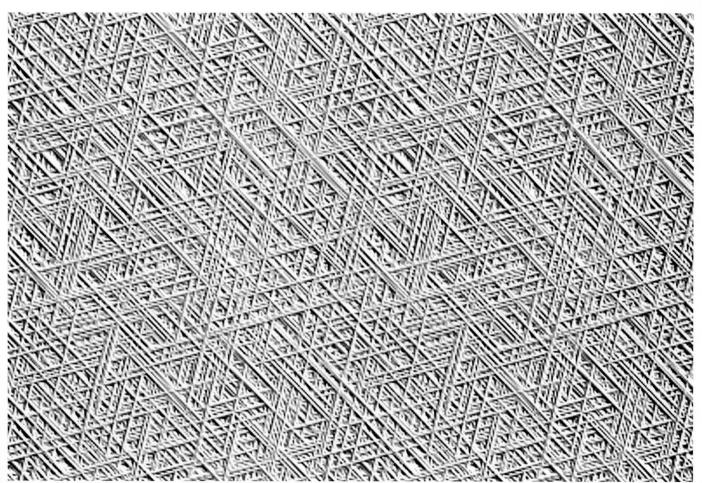

Fibers and Fabrics

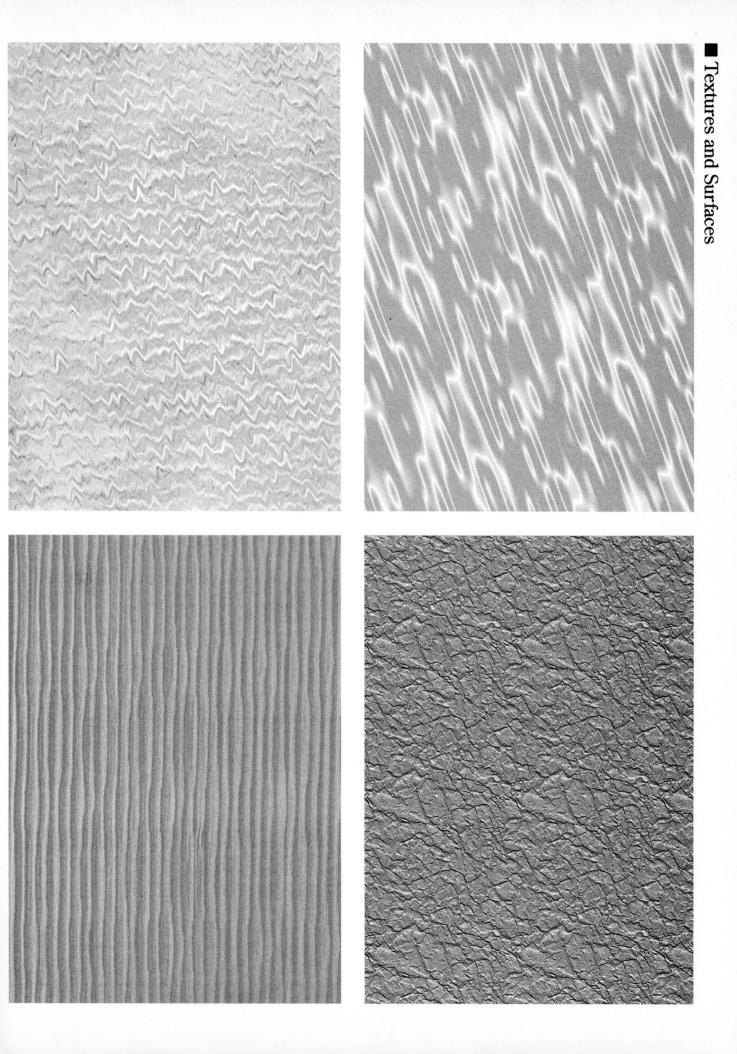

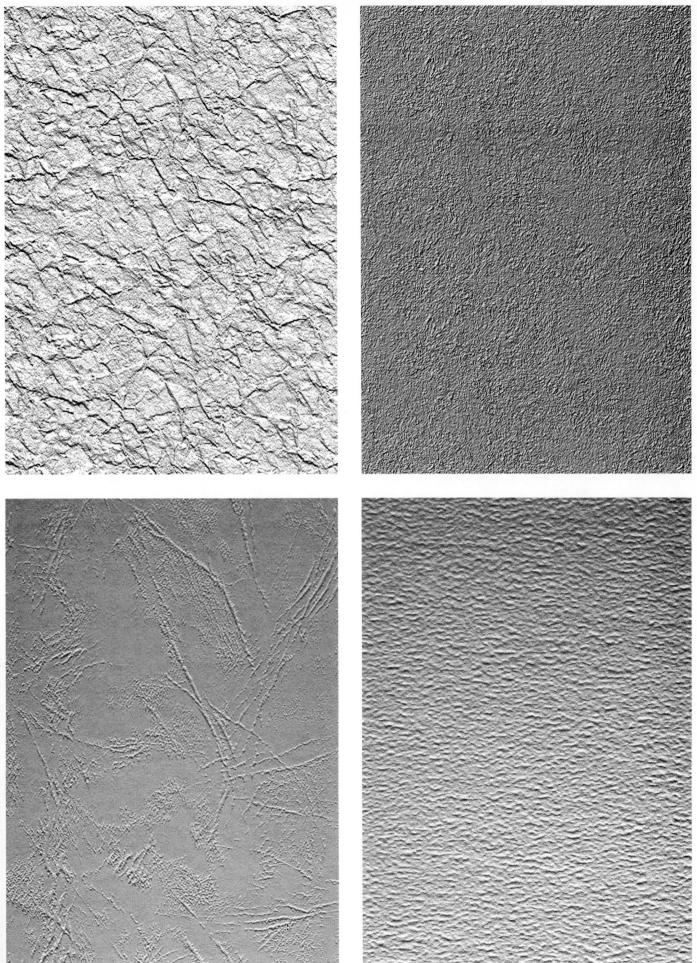

■ Textures and Surfaces

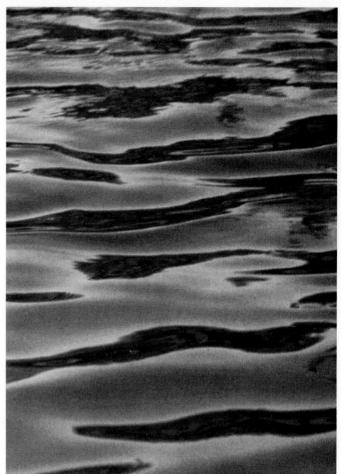

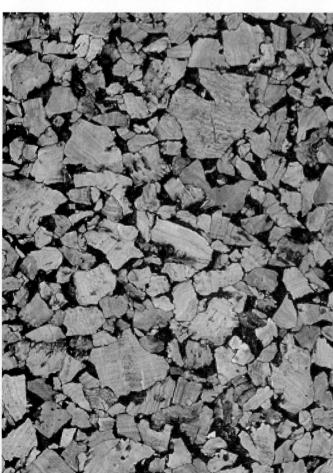

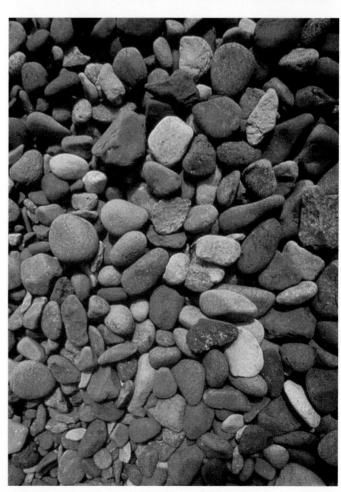

■ Textures and Surfaces

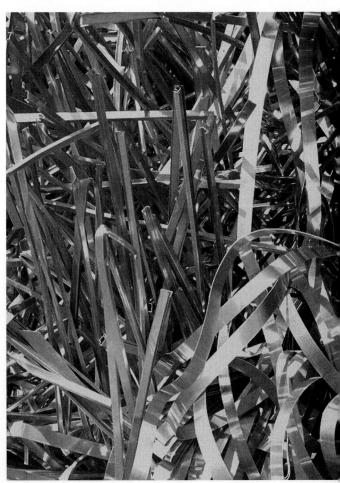

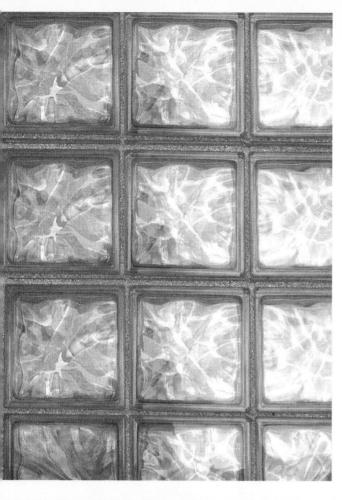

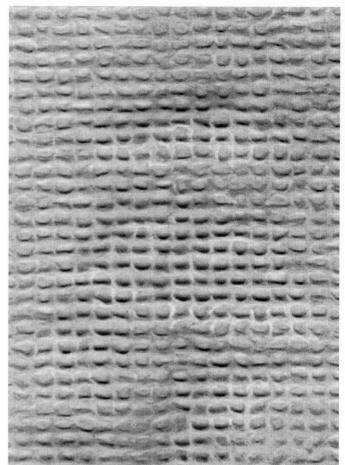

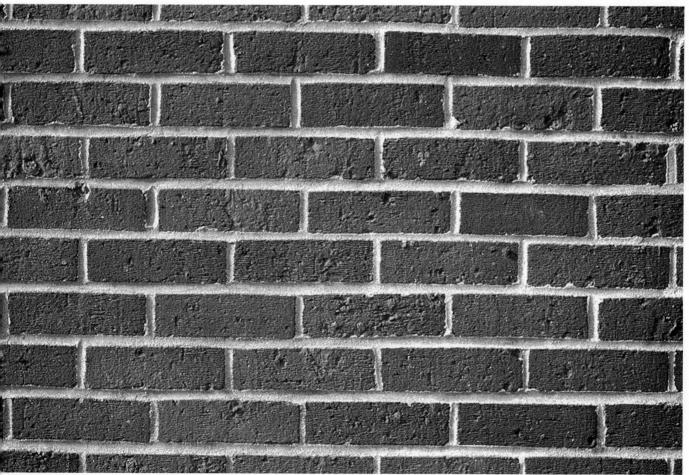

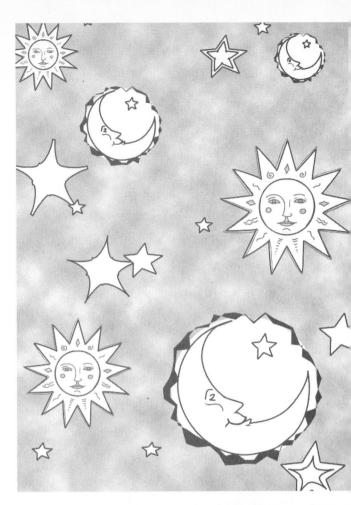

PPY BIRTHDAY!
BIRTHDAY! · HAPPY
DAY! · HAPPY BIRTHDAY
Y! · HAPPY BIRTHDAY
APPY BIRTHDAY
HAPPY BIRTHDAY!
BIRTHDAY! · HAPPY
DAY! · HAPPY BIRTH
J! · HAPPY BIRTH
J! · HAPPY BIRTH
J! · HAPPY BIRTH

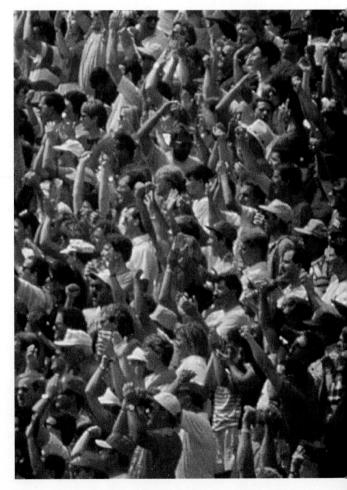